Learn Drawing
Quickly

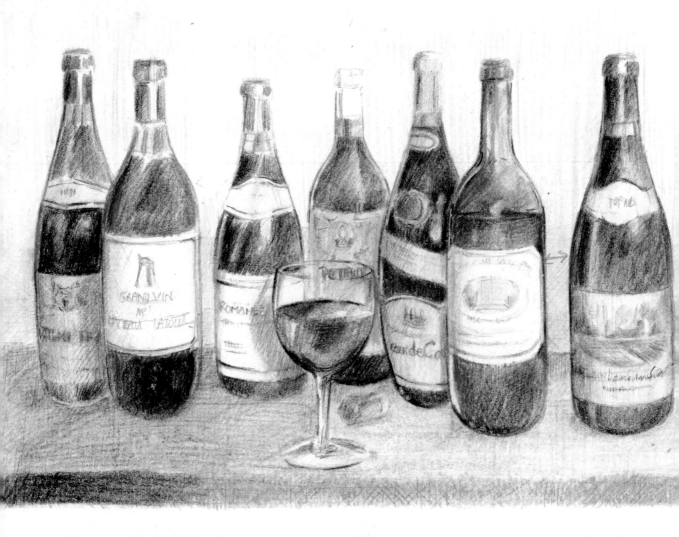

Sharon Finmark

Learn Drawing
Quickly

BATSFORD

First published in the United Kingdom in 2016 by
Batsford
1 Gower Street
London WC1E 6HD

An imprint of Pavilion Books Company Ltd

ISBN: 9781849943109

A CIP catalogue record for this book is available
from the British Library.

10 9 8 7 6 5 4 3 2 1

Reproduction by Mission, Hong Kong
Printed and bound by Times Offset (m) Sdn Bhd, Malaysia

This book can be ordered direct from the publisher
at the website:
www.pavilionbooks.com, or try your local bookshop.

Contents

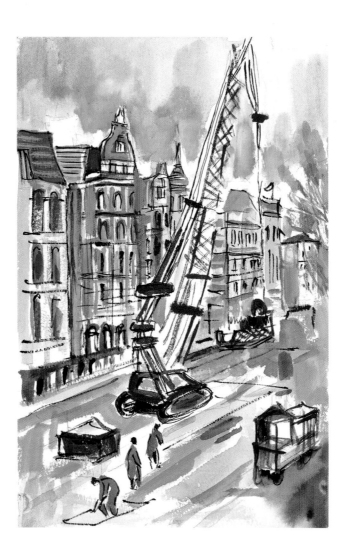

Introduction

A drawing may be a swift sketch, a careful study, a visual diary of your life or just something done for sheer creative pleasure. Drawing is all about ways of seeing and methods of translating that on to paper.

This book starts with simple exercises and ideas, encouraging an inventive approach to composition and helping you to develop your own personal style. You will explore the shapes of everything you might choose to draw and the materials that suit both you and your subjects, learning how to build up lively drawings where all the elements combine to make interesting and successful pictures.

Page 2: Wine bottles in coloured pencils. I overlayed several colours to create the deep reds of the wine and the white of the paper showed up the highlights on the bottles.

◁ Construction site in the City in brush pen and watercolour. The red of the crane was a great contrast to the grey of the sky.

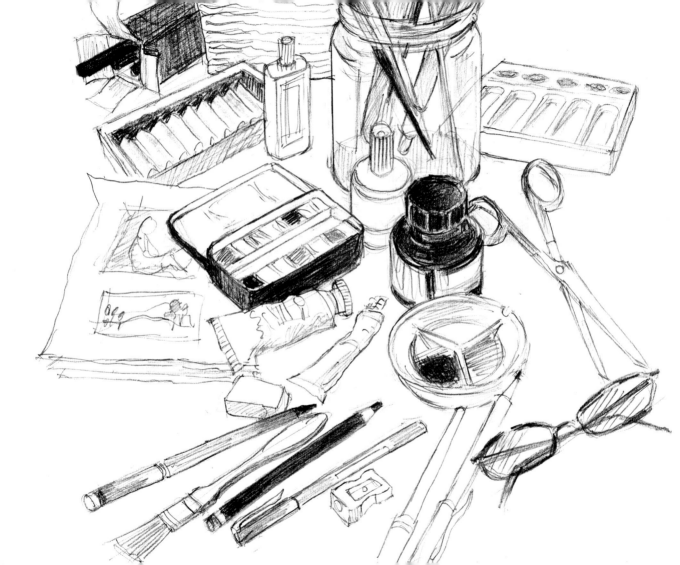

Chapter 1
Materials and mark-making

The range of drawing tools is wide, and it's exciting to explore what the different media can do. In this book you'll discover the textures that are possible and their potential use, so that you can build up a vocabulary of marks. Popular and easy to obtain drawing tools include pencils, charcoal, chalks, pastels, pens and paint applied with a brush or pen. You will also need erasers and cartridge paper, both textured and tinted.

◁ A selection of pens, pencils, paints and inks can be acquired inexpensively, along with a few essential accessories. Their familiarity makes it easy to begin drawing.

Drawing materials

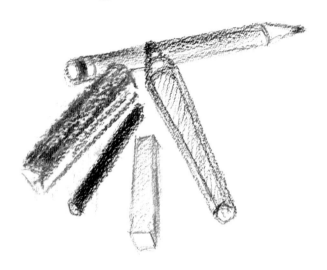

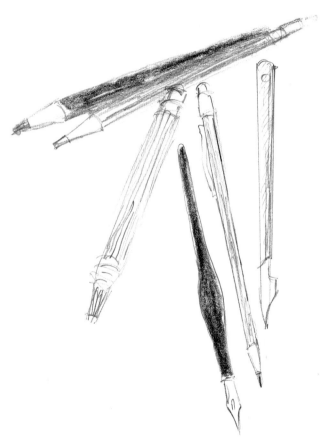

△ Soft-textured drawing tools include square-ended pastel, conté, compressed charcoal, fine charcoal, pencil and fat graphite pencil.

▷ Propelling pencils and dip pens give clean, precise marks.

I use black Indian ink with a wide, soft-haired brush and watercolour with a smaller soft-haired brush. The diluted ink and paint both offer tone but the ink sinks in more quickly and has a slightly different quality of black, with more intensity. Using a pen in combination with a brush is effective.

Watercolour tubes offer more paint than pans (small blocks) and thus stretch to a larger drawing. The paint is exactly the same.

Textures in charcoal and pencil

To begin with, don't try to draw whole objects that have pattern and textures – just experiment with how to show their surface. Consider drawing the textures of an onion, wire, string, pebbles, shells, metal and so forth – anything that has a surface you like – and enjoy the marks for themselves before you move on to drawing the objects as a whole.

▷ Looking at ordinary fruit and vegetables offers the opportunity to see very simple basic shapes and how to create a texture on them. The textures in the top group are in charcoal, showing the stippling, broken marks, fine lines and blending that you can achieve using this medium. The same objects shown below demonstrate how pencil can more delicately achieve both texture and shadow.

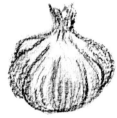

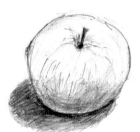

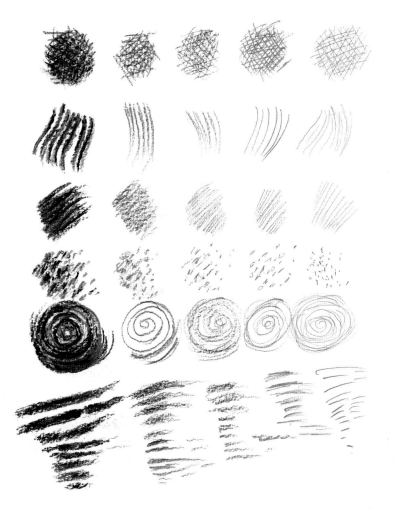

These range from vigorous to more refined marks, using charcoal, charcoal pencil and soft 8B to harder HB pencil marks. The softer, more intense drawing tools are well suited to shading and the lighter ones to detail. Using your finger to smudge the charcoal is a swift way to shade it for a velvety feel.

Textures and marks in hard pencil

The long, wavering line across the page shows the range of soft to hard pencil marks. The other marks are further examples of what you can elicit from the range of pencil grades. Try the various methods of building tone given here and use the ones most suitable for your subject matter. Drawing closely spaced parallel lines, then laying a second set across them at right angles (known as cross-hatching), works well for natural objects such as shells or woven baskets.

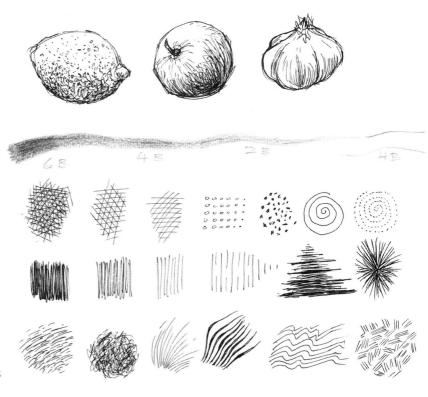

Using pen, you can make scratchy lines to show a surface, building up to overlapping lines to indicate the darker tones, such as the interior of these shoes. You may get blobs of ink when you use a dip pen, but these can be interesting marks rather than faults.

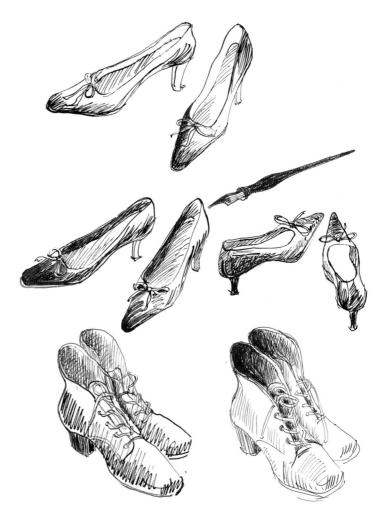

Coloured pencils

Coloured pencils are used in the same way as an ordinary pencil, but have the advantage that they give you the ability to overlay one colour with another with a delicate touch.

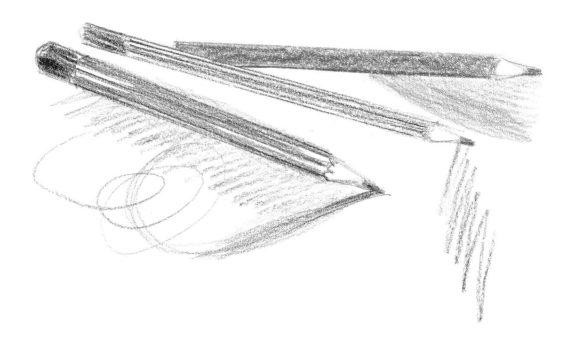

Pastels

Pastel crayons may be rounded or squared along their length. By using the side of the crayon rather than the tip you can create large textured areas, especially on textured paper intended for pastels. If the drawing has strong contrasts, using tinted paper allows you to add white to show highlights.

Pastels can be smudged and rubbed into the paper to blend colours, though they won't mix in the same way as paint.

Coloured felt-tip pens

These are usually rather bright in colour, so unless you buy a vast range they don't lend themselves to subtle representation. For different marks, buy them with tips of various sizes from fine to broad.

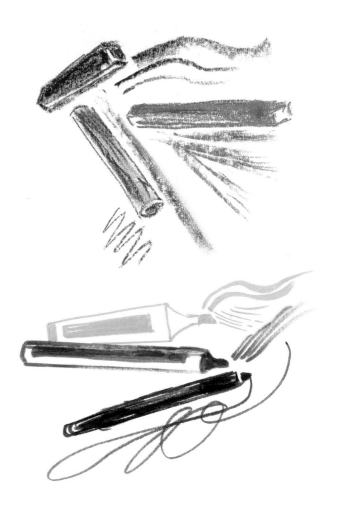

Textures in coloured pencils, pens and pastels

The lemons, apples and garlic here are drawn in coloured pencils (top), felt-tip pens (below) and pastels (opposite, top); they all have different qualities. With all the materials used, following the form of the object with your marks, be they stippling, lines or smudges, will give the appearance of solidity. For example, stippling is ideal for the pitted texture of lemon peel and increasing the density of the dots at the underside creates a three-dimensional appearance.

Felt-tip pens are quite permanent, so you need to be fairly confident with your mark-making, whereas the smudgy pastel technique is more forgiving.

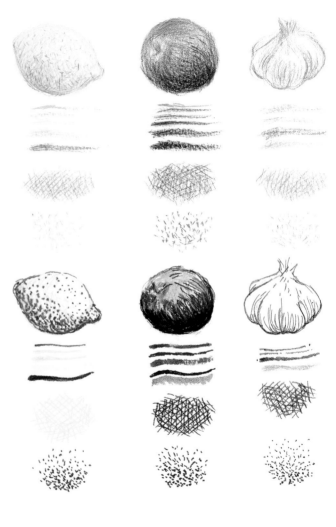

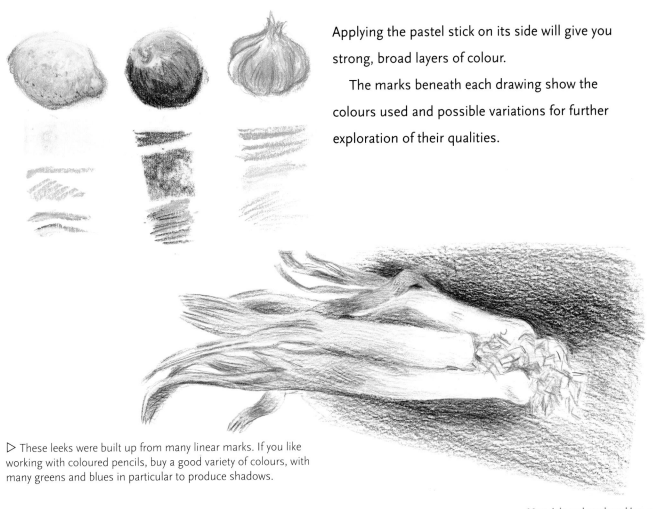

Applying the pastel stick on its side will give you strong, broad layers of colour.

The marks beneath each drawing show the colours used and possible variations for further exploration of their qualities.

▷ These leeks were built up from many linear marks. If you like working with coloured pencils, buy a good variety of colours, with many greens and blues in particular to produce shadows.

▷ Make the most of the intense colours of felt-tip pens by being imaginative. In this fantasy city against the night sky, the marks are limited to fine lines or broad sweeps of colour from fat felt tips.

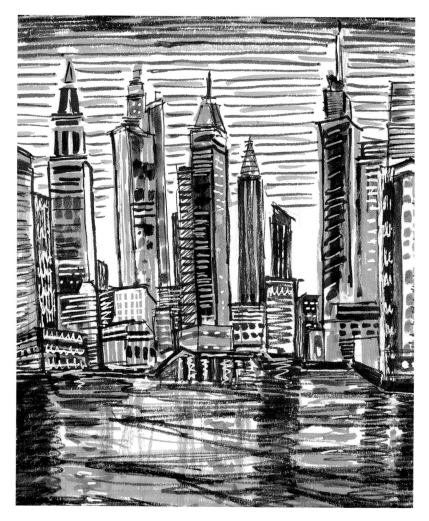

∇ The choice of the paper for the mushrooms was led by their colour, so that the drawing emerged with the emphasis of the dark surround and the light ribs on the stalk.

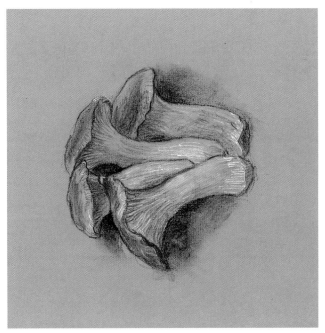

△ I used slightly textured tinted paper for these drawings. It works well with pastels as you can bring out the light areas with white pastel, rather than relying on the white of the paper. The texture means that the pastels, which can be a little volatile, will sit in the tiny grooves. You can use fixative (or hair spray) to prevent the drawings from smudging.

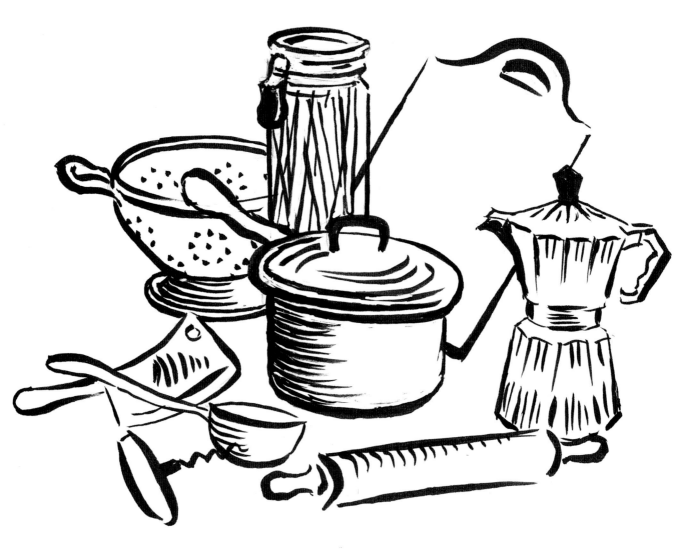

Chapter 2

Shape and form

The world is made up of basic simple shapes; most forms can be reduced to a cube, a sphere, a cone or a cylinder. You'll find that observing and analysing objects in terms of these underlying shapes will really help you to draw them, whether you are tackling an apple, a teapot or a large, complicated building. It's possible to reduce everything, including the human figure, to a simple starting point.

◁ For this drawing of kitchen objects in brush pen I chose a stark linear look, using different pressures of the pen to emphasize their curves. They are all made up of basic shapes; even the coffee pot can be simplified down to two triangles. If you are daunted by the complexity, always start with the core basics and elaborate later.

Basic shapes

We are comfortable with the shapes of a cube, sphere, cone and cylinder since we have known them since we were infants, learning how to fit brightly coloured forms together. Hence, reducing more complicated objects to a starting point of one of these shapes immediately makes us feel more confident. Even a complete beginner to drawing can feel that this is something they have experience in handling.

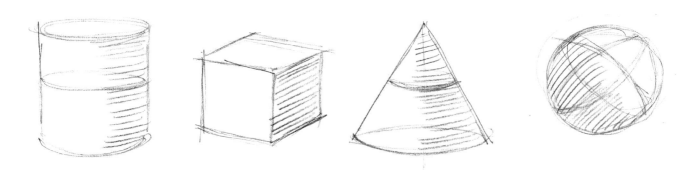

△ These pencil drawings show a cube, sphere, cone and cylinder, given shading so that they look solid and three-dimensional.

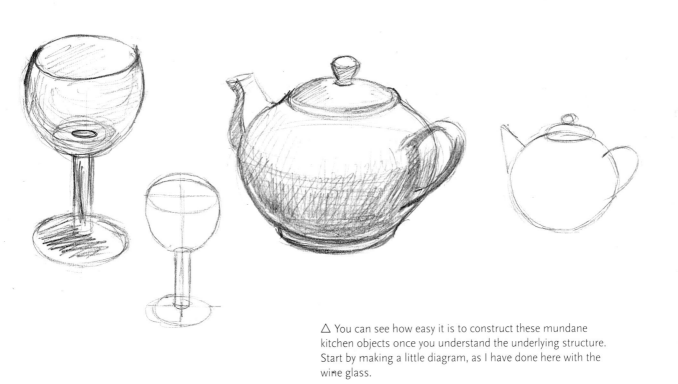

△ You can see how easy it is to construct these mundane kitchen objects once you understand the underlying structure. Start by making a little diagram, as I have done here with the wine glass.

Making the ordinary special

Very ordinary objects found in your kitchen are a perfect way to start as they have familiar and often interesting shapes.

The hanging kitchen tools in bright colours on pages 28–9 and the shelf with the radio on the facing page are all made up of those basic shapes. In the latter composition, I put in the shadows cast on the surface as they ground the image, and added just a touch of colour to brighten the drawing. The combination of pencil and paint works well, with the use of the primary colours, blue, yellow and red, against the stark white paper. The subject might seem ordinary, but by clever use of drawing materials, anything can be made worthy of a drawing.

▷ Here is a shelf, with no rearrangement – I drew it just as it was, with the sun glimpsed beneath the blind.

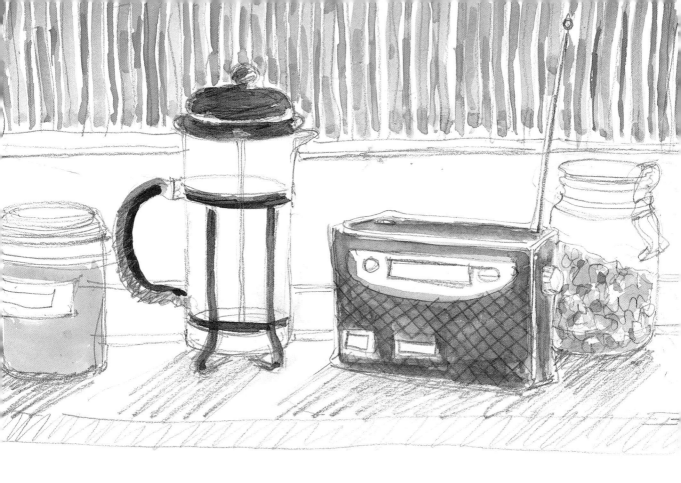

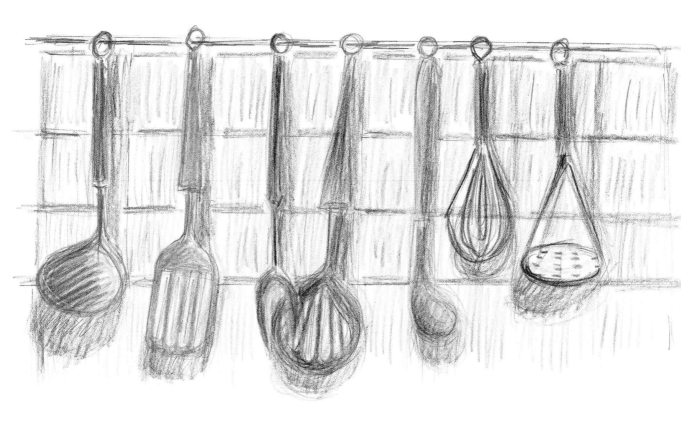

Look at your kitchen utensils and focus on how you can reduce them to simple shapes. Because mine are hanging up they look flatter, so in my drawing they become ovals and circles. I was attracted by the bright colours and used coloured pencil and watercolour to liven up a rather mundane subject.

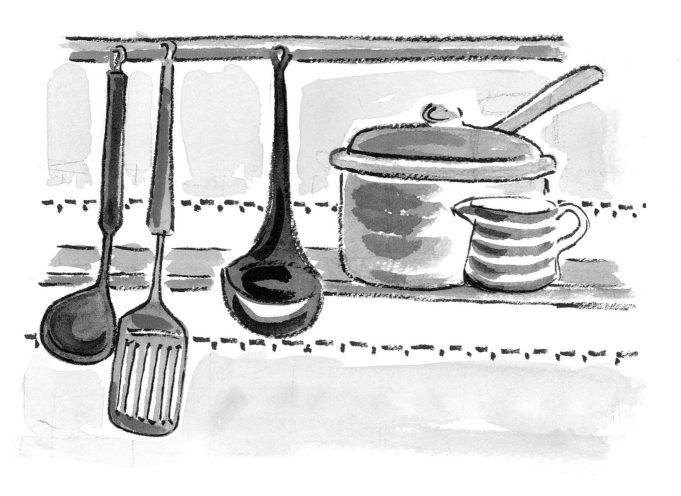

Angle of view

Of course, the basic shapes we have discussed will appear to change depending upon the angle from which you look at them – straight on, from below or from above. For example, a cup's rim is actually circular and is evidently so when you look straight down on it from above, but it looks oval when viewed from a lower eye level, progressively flattening as your angle of view drops until it appears to be merely a straight line. This applies to all circular objects such as tables, bowls, bottles, wine glasses, plant pots and so forth. These foreshortened circles that you see are called ellipses.

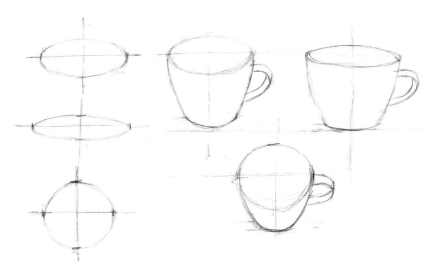

▷ Drawing a central horizontal line across an ellipsis and bisecting it with a central vertical line will help you to draw the perfect shape for your angle of view.

Ellipses can be tricky to draw – common errors are to bring the sides together into a point, or to make the ellipsis lopsided. To reproduce an ellipse accurately, draw a horizontal line across the centre of your shape. Cut it down the centre with a vertical. Draw a curved line over the horizontal which is equally bisected by the vertical, then draw a mirror image below the horizontal. All four parts should be equal, giving you a perfect ellipse.

▽ If you are drawing a circular, transparent, object such as a glass, the ellipsis at the base will match that at the top. When you view a circular object from below, the rim will appear to curve upwards.

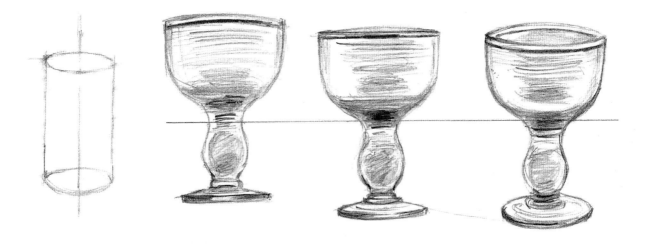

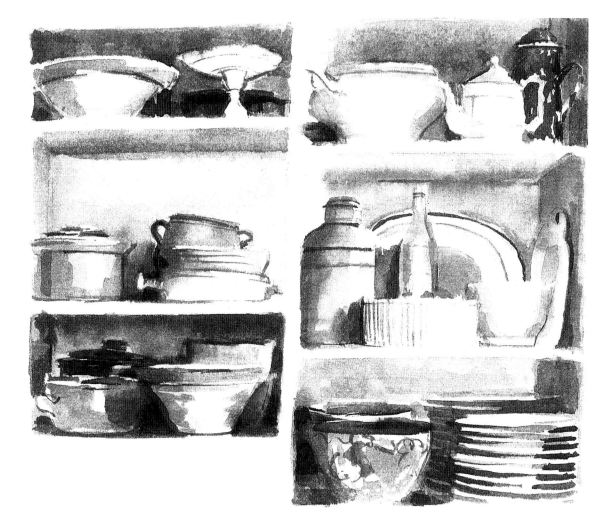

Chapter 3
Tone and form

In this chapter we'll explore how to show different tones to achieve solidity of form. This means using light and shade in a way that will make your drawings appear three-dimensional even though they are on a two-dimensional piece of paper.

In the first chapter you learnt about different ways of making marks and now you'll discover how to use them for effect, focusing first on identifying the darkest tones, then the lightest and next all the subtle in-betweens – the mid-tones. Depending on the drawing tools you are working with, you can vary the tones with the density of your cross-hatching, for example, or erase smudged charcoal to reveal highlights and mid-tones.

◁ The shapes in this drawing of shelves stacked with crockery are largely defined by light and dark tones.

Finding the form

For your first tonal drawings, try a simple set-up with a direct light source falling on it. It's easiest to begin with well-defined shadows, so if natural light isn't providing enough contrast of tone, set up a lamp to one side of the objects.

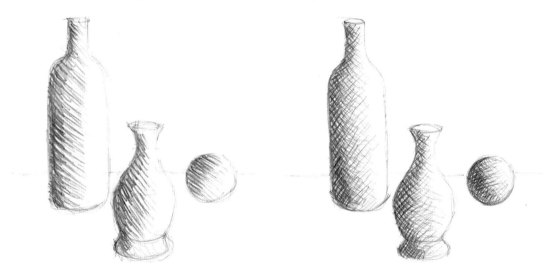

Draw a series of angled lines on the shadowed side of the objects and build up the darkest areas by overlaying with even more lines – a technique known as hatching.

Alternatively, you can build up tone in much the same way by taking the opposite angle with the second set of lines, creating a mesh. This is cross-hatching.

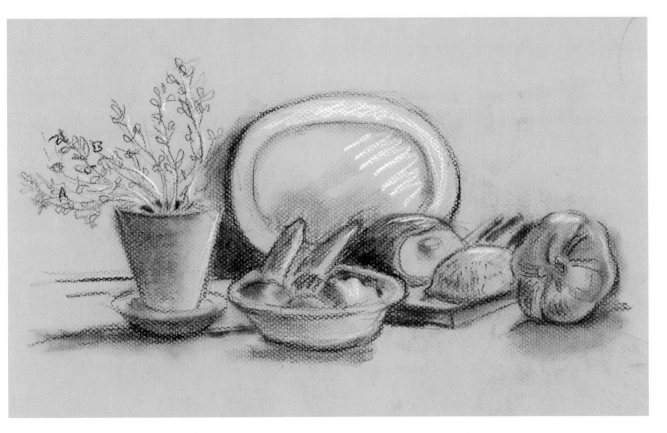

This still-life drawing is made with charcoal on tinted paper, using white chalk for the touches of light and the side of the charcoal to describe the obvious shadows.

Tonal drawing with pencil

Once you feel confident about drawing a simple set-up, you will want to progress to more complicated themes such as landscapes and interiors.

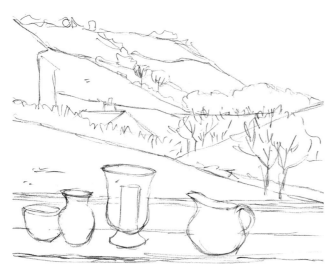

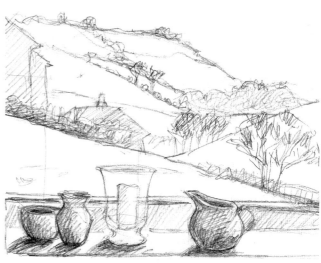

STAGE 1
Start with just a pencil line to put in the row of foreground objects and the scene beyond, noticing the overlap of one object over another and the differences in proportion and shape.

STAGE 2
Next, add the tonal values using light marks and build over them to make up the darkest areas. If you find it tricky to distinguish the variety of tone, screw up your eyes and peer through half-closed lids – it will eliminate detail, making the tonal range more obvious.

Looking through a window gives a natural composition that combines foreground and more distant views. If your view is complicated, just simplify it or try another window. The light conditions will have an effect on how your subject looks, so if you are working with natural light you may need to come back to your drawing at the same time on another day.

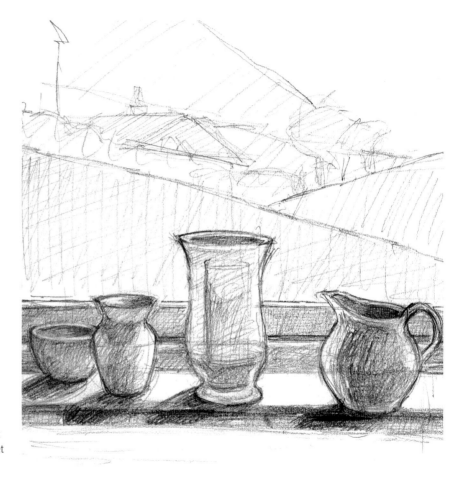

▷ Here is a close-up of those objects with the landscape even less emphasized. This lighting is called *contre-jour,* meaning against the daylight. The objects have light only on the rims. You have the power to set up interesting and even dramatic set-ups by playing with light, artificial or natural.

Exploring tone

Once you have gained some confidence in working with tone, take a sketchpad and drawing tools out and about with you and tackle more complex subjects. This doesn't necessarily mean working more slowly – a lot can be captured in a quick sketch.

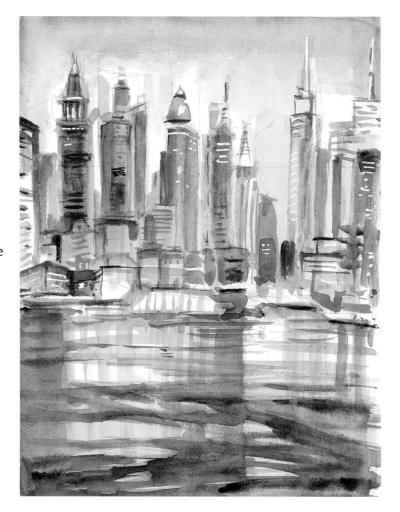

▷ Because the windows here are tiny I used a white uniball pen to put them in over the dark areas rather than leaving white paper. To create the distance in the water I made the nearer ripples broader than the receding ones. Note that the reflections are directly under the buildings.

Choose your medium to suit your subject, as I have done in the drawings here. With watercolour, start with washes of very diluted black paint to block in the shapes and then build up to the darkest areas, leaving white paper for the highlights.

The saxophonist is drawn in charcoal, which seemed the right material for the moody atmosphere as it offers lovely velvety blacks.

▷ I was sitting upstairs so my viewpoint was a high one, looking down on the figures. The room was dimly lit apart from spotlights, so there was plenty of contrast between intense darks and sharp highlights.

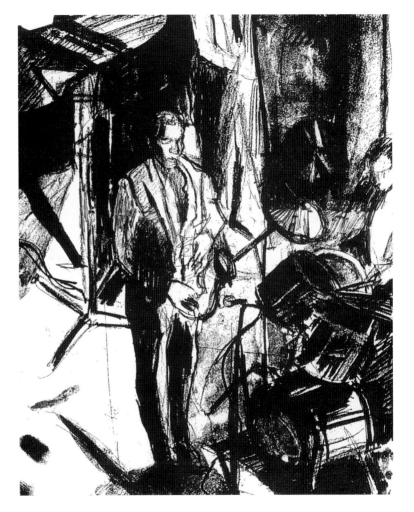

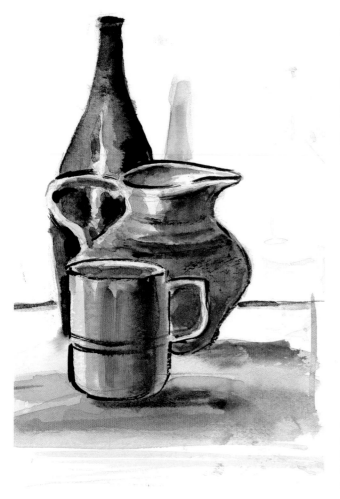

Tone with ink and wash

Ink can give very intense dark tones, so use a saucer to mix it with water and experiment with the dilutions you will want to use for your drawing before you start.

◁ Here are the basic rounded shapes again, in very different sizes and overlapping each other. This gives interest and makes you look carefully at the relationship between them. Note how the bands of shadow on the cup gently overlap to make a gradual shadow that reveals the curve of its form.

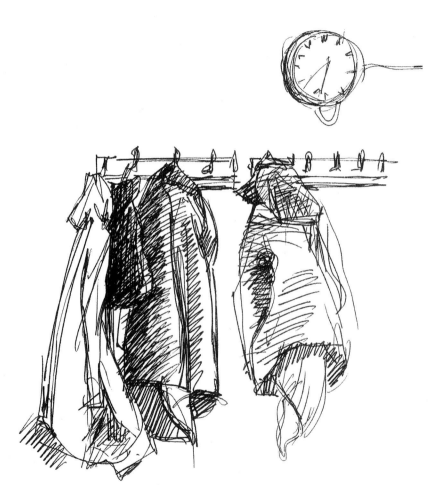

◁ Here is a quick sketch in scribbly ink of coats on hooks. The energy hopefully describes the way coats are swiftly hung up in a haphazard manner.

Tone with charcoal

This interior faces towards a window which throws light on the table and the window bars become dark, as does much of the interior. Instead of drawing with line to establish the composition, cover tinted or white paper with a coating of charcoal to produce a middle tone then lift out the lighter tones with an eraser and emphasize the darker ones. It's another way of looking at a composition and seeing the drawing emerge. Not only is it fun but the technique could be used to create mood. As it is a looser way of working, it suits drawings that are less defined.

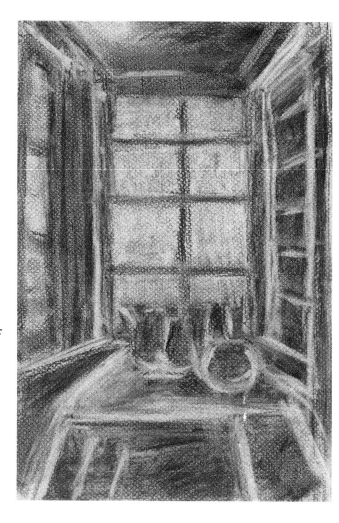

STAGE 1
Rub in the charcoal with a cloth or your hand – not too hard or it will be difficult to lift off. Then start to take out the light areas with an eraser, rubbing gently for the slightly paler tones and harder for those you want lighter still.

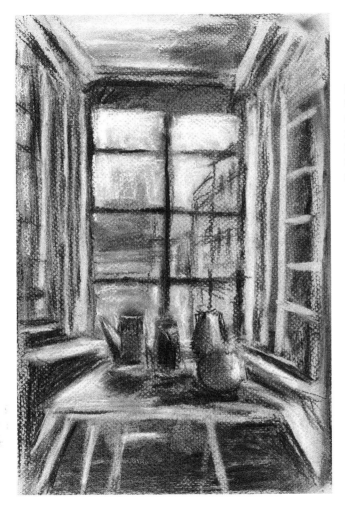

STAGE 2

Gradually add the darker areas with more charcoal. The very lightest areas could be made with white chalk on tinted paper, but if you are working on white paper just leave the paper for the highlights. This way, the composition is laid out by the erased lines.

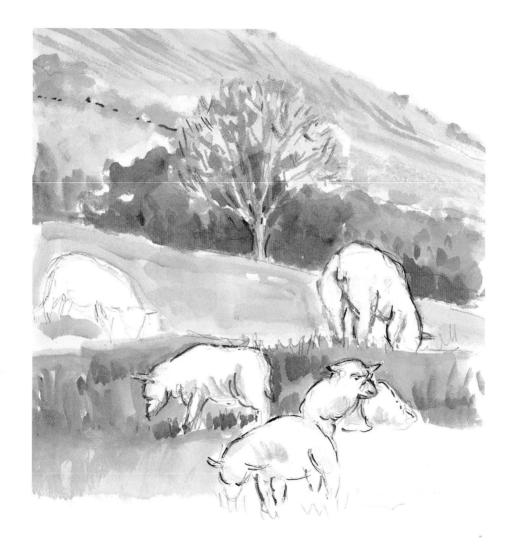

Chapter 4

Composition

Composing a picture is a matter of choosing from the subject matter, deciding what to include and how the different elements will relate to each other. By forming the design rather than just accepting what is there you will produce a better drawing. Whether your subject is a still life, a landscape or part of an interior, checking the proportion of one object to another and the shapes in between are part of the drawing process.

The first decision is whether to draw in a landscape (horizontal) or portrait (vertical) format on the paper. A viewfinder will help you choose which is more effective for a particular scene and how much of the scene you want to show. Choosing to sketch a whole room or a small intimate corner will create images with completely different moods, as will the viewpoint you choose.

◁ The composition here is based on diagonals, with the land sweeping down and the foreground sheep at an opposing diagonal.

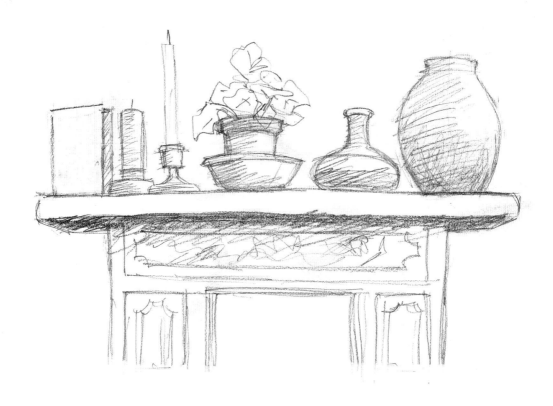

△ This is drawn from a low viewpoint, so you can see the upward curve of all the horizontals, including the angle of the shelf.

Finding your viewpoint

To help you choose your compositions, acquire a simple viewfinder. This is simply a rectangle of cardboard with a smaller rectangle cut out in the middle – you can make your own or buy an inexpensive window mount intended for framing a small picture. To experiment with your view, hold the mount at arm's length, close one eye and look through the window, moving the mount up and down, from side to side and nearer to you. If you have a mobile phone or a tablet with a camera, you can use it in the same manner.

The eye level you decide upon will be a major factor in the drawing, since shapes alter depending on whether you are looking up or down at them.

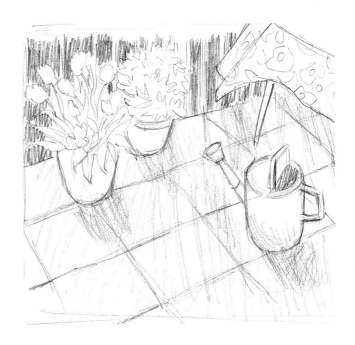

△ For this pencil drawing, I looked at the plants and watering can on a patio from above. The angle of the paving stones, which are almost square, show this clearly.

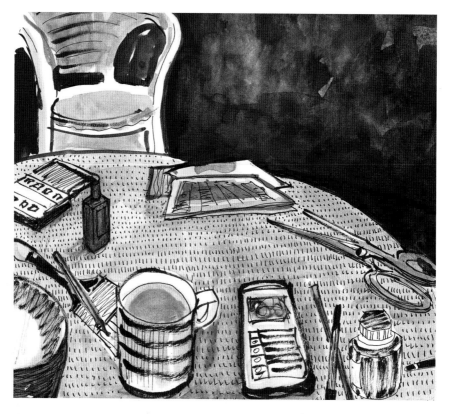

△ Looking up at the shelf above the fireplace on page 46 you cannot see into the objects, but this higher viewpoint looking down on a coffee table gives a view of their interiors. The mark-making here is a mixture of ink washes and dried pen marks. Everything is scattered and natural, as you might have left your table. The style is also casual and not truly representational – the proportions and angles are not necessarily accurate.

In both compositions here some of the objects come out of the edges of the frame, which makes for a more dynamic drawing and avoids a tight composition sitting in the middle of the paper. It also leads on to more experimental ways of working towards abstract shapes rather than visual representation. We are all slightly scared of veering away from exactly what we see in front of us when drawing.

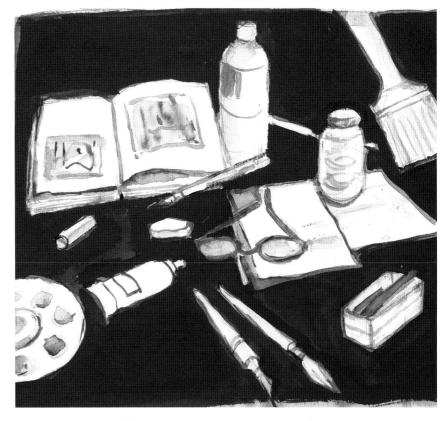

△ The shapes between objects, known as the negative shapes, are as important in a composition as the objects themselves. Again using ink and wash, I have emphasized the negative shapes here by blacking them in.

Choosing the view

There is no 'correct' selection of any subject, but the more thought you give to the framing and angle, the more likely it is that you will produce a dynamic and intimate design.

This is an example of a broad expanse of landscape from which I needed to select elements in order to make a successful drawing. The view had plenty of potential for different selections. You won't always have a window to act as a frame, but your viewfinder does the same job.

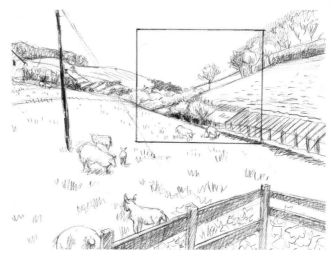

First, I drew the whole view I could see from my window. It was a perfectly pleasant scene, but I wanted just a part of it so I tried framing smaller compositions within it.

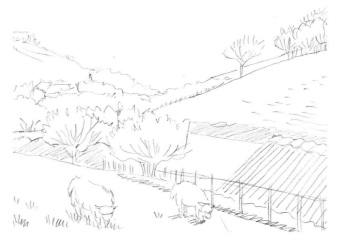

I selected a view that was more compact and sketched in a line drawing first.

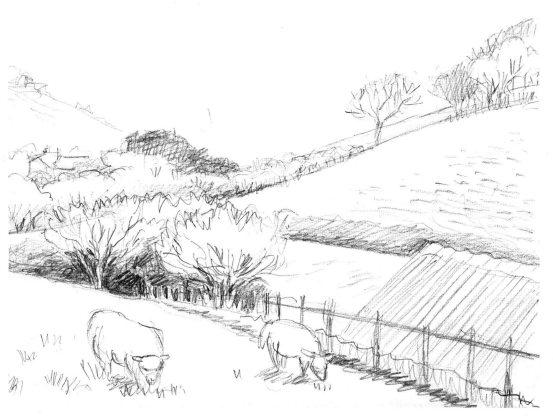

Next, I gradually built up a tonal drawing. I put in the shadows beneath the trees and stressed the shapes of the sheep, the texture of the grass and the broken marks that indicated the hilltop.

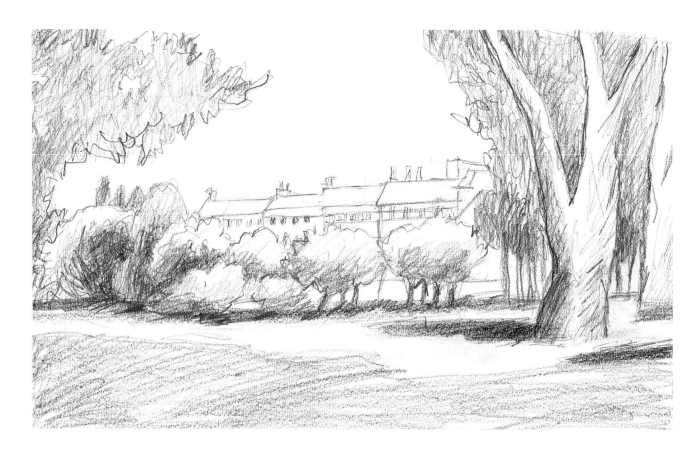

When you discover a location you particularly like, you can make the most of it by doing two drawings but moving in closer for one of them to gain a very different effect.

The larger view is nicely contained by the trees in the foreground, while the smaller, more square view zooms in on the houses and one tree clearly coming out of the rectangle. Strong shadows make a simple view dynamic but believable.

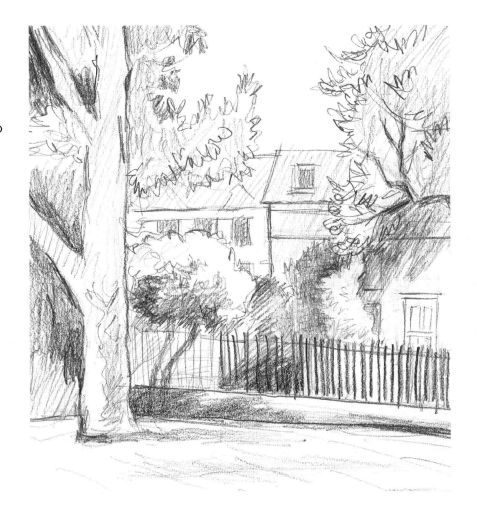

These coloured drawings were all about an intimate corner, looking down at a very small selection of objects that caught my eye. The flowers are a good foil for the more solid bucket, pots and broom.

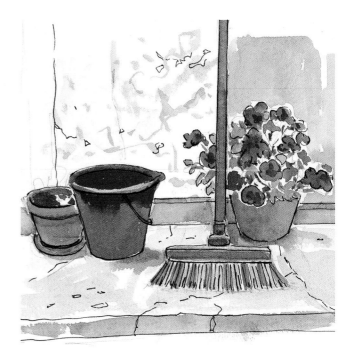

△ Here I have selected a close view from a high angle, looking down on the objects. I used a combination of watercolour and pen line. The selection of objects occupies the foreground.

▷ This watercolour drawing of a watering can on the patio was made by standing above it so the lines of the paving slabs draw the viewer into the drawing. With both drawings the viewpoint made all the difference.

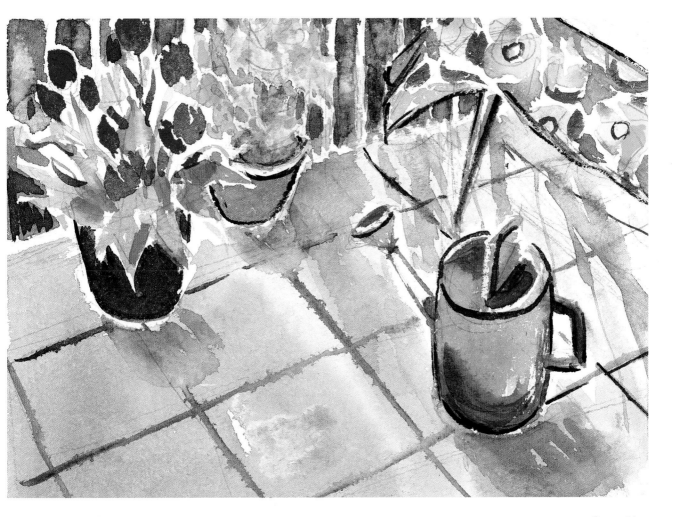

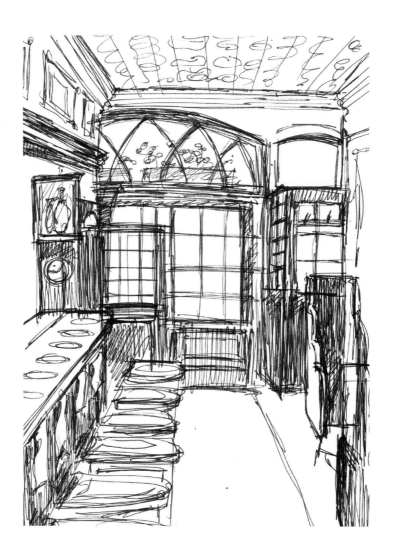

Chapter 5

Basic perspective

Perspective is a method of conveying the appearance of distance and three dimensions on the flat, two-dimensional surface of paper. The rules of perspective are potentially daunting, but it will help matters if you keep your approach simple and refer back to those fundamental shapes. An understanding of perspective is necessary if you want to be able to draw a set of convincing buildings, a street or an interior.

◁ Here the use of perspective gives depth to the room, leading the eye along the bar and to the end window.

Types of perspective

Single-point perspective addresses objects with their closest plane parallel to the horizon. If you were to stare straight ahead at the horizon behind them, the point on the horizon directly in front of you would be considered the vanishing point.

Perspective is gauged by drawing lines from the top and bottom of the front face of an object such as a building to converge and meet at the vanishing point. Successive buildings and their windows will become increasingly diminished, bounded by those two lines, the closer they are to the horizon.

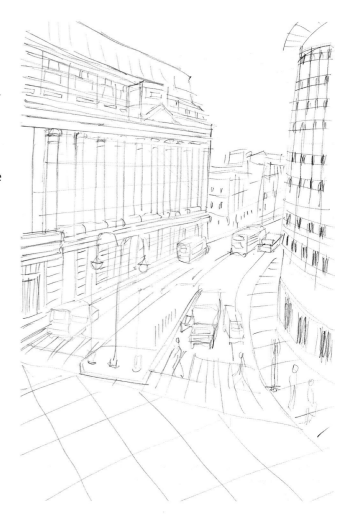

If the horizontal lines of a building, or any other object, are not parallel to the horizon, you are in the realms of two-point perspective. For this, two vanishing points are needed, though one may be extended out of the drawing. The vertical edges of the building will remain vertical in the drawing; it is only the horizontals that are affected.

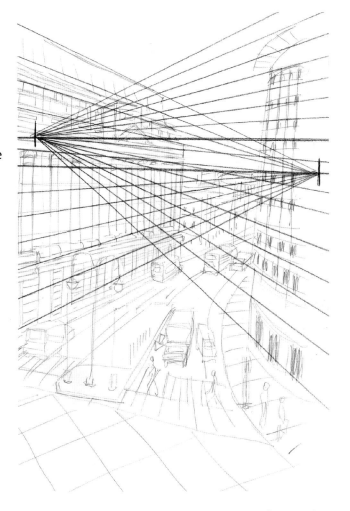

Shown here is a city street in pencil (left) with an overlay of the two-point perspective (right). The lines converge at two points. The eye level is high.

As an aid to judging the position of your eye level in relation to the objects in front of you, draw some parallel horizontal lines on a piece of glass. Hold the glass at arm's length in front of you, with the centre line level with your eyes. The other parallel lines will help you see more clearly the angles created by the objects you are looking at: those above slope down and those below slope up.

In most drawings there is more than one vanishing point, especially indoors, where furniture is usually arranged at different angles, so each has its own vanishing point.

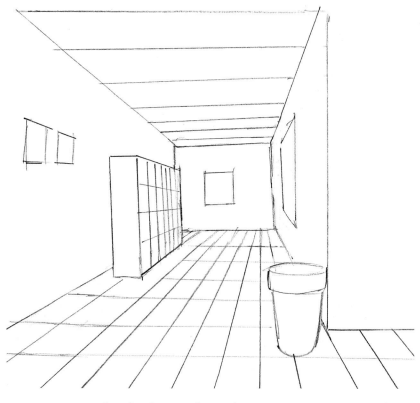

△ In this diagram of a corridor using one-point perspective the lines all converge as they recede from the viewer. Note how big the bin looks, which helps the visual deception.

▽ Because the sofa backs are parallel to the walls and the coffee table is parallel to the sofa the vanishing points in this drawing are only two. They run out of the drawing to the left and right.

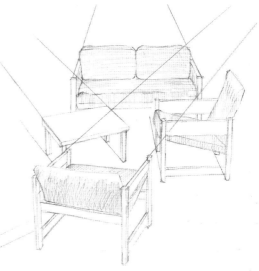

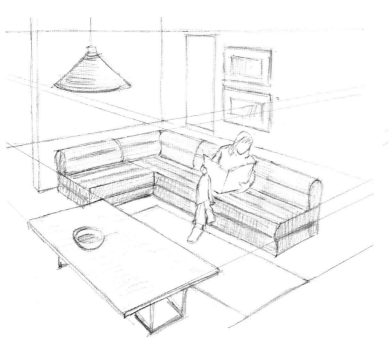

△ This appears more complicated but is a more common situation, where the lines taken from the table and chair edges create their own individual vanishing points. Don't be too worried about this – creating a happy perspective is primarily a matter of careful observation and reproducing what you see.

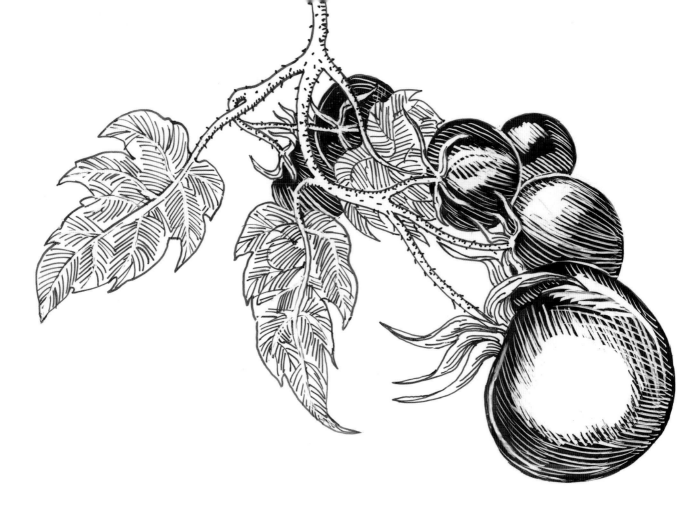

Chapter 6

Drawing styles

The drawing material you choose and how you handle it will affect the look of your work. After some experience of drawing, everyone tends to find a style that they enjoy and do particularly well. Before that can happen, though, it's a matter of spending some time exploring different approaches and materials and even combining them. There are no rules – the styles described on the following pages are only intended to emphasize the possibilities.

◁ This drawing of a tomato plant in pen and ink is rendered with a strong contour line to mimic the look of a woodcut.

Contour drawing

The practice of contour drawing is a very clear, controlled, linear approach where your focus is on the outline, or edge, of objects. Choose a place to start and put the point of your pencil there. Imagine that it is actually touching the object and, without taking your eyes off the object, wait until you feel convinced of this. Then move your eye slowly along the contour, co-ordinating your hand to move the pencil equally slowly along the paper. Be guided more by the sense of touch than by sight – you will find that your eye will be tempted to move faster than your pencil.

▷ The edge of this checked shirt is considered and the checks are also fundamental to how the fabric folds and hangs, so the linear pattern follows that inner edge too.

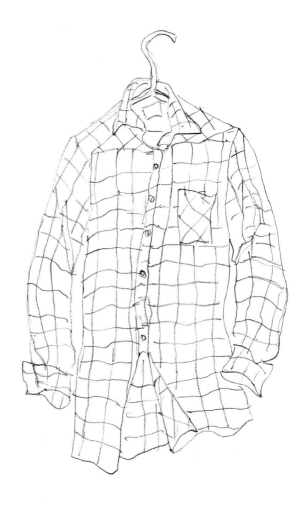

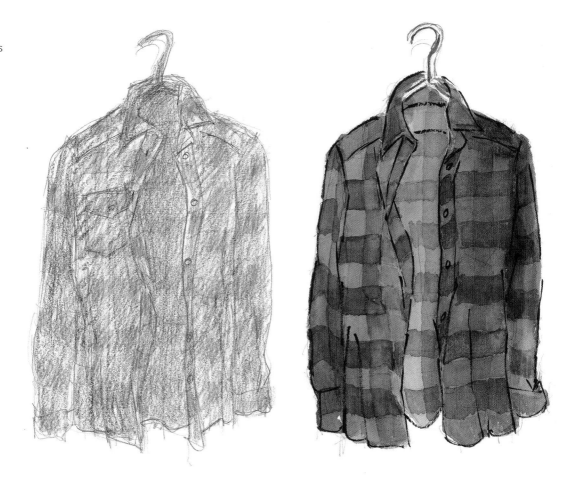

▷ These drawings are just fun developments of the basic first contour drawing, showing how to combine colour and shading with coloured pencils and watercolour.

Continuous line

This technique is much as it sounds: the drawing is done continuously and at a constant speed without lifting the hand from the paper. Progress through the drawing rhythmically and slowly. It will inevitably have a network of lines overlapping each other that escape from the strict contour, as you are not taking the pencil off the paper to get from one point to another. The effect can be seen as messy, but it's lively and creates a loose, impressionistic drawing.

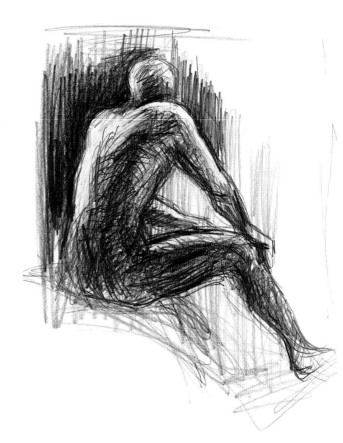

▷ In this example of tonal progression with continuous line, the areas of tone are built up at the same rate. As far as possible I kept the pencil on the paper as it travelled, feeling the form of the body.

▽ These are very swift sketches, keeping the pencil on the paper to use a continuous loose line. Cats are perfect for observation while they stretch and curl their bodies around. Their features form a small triangle.

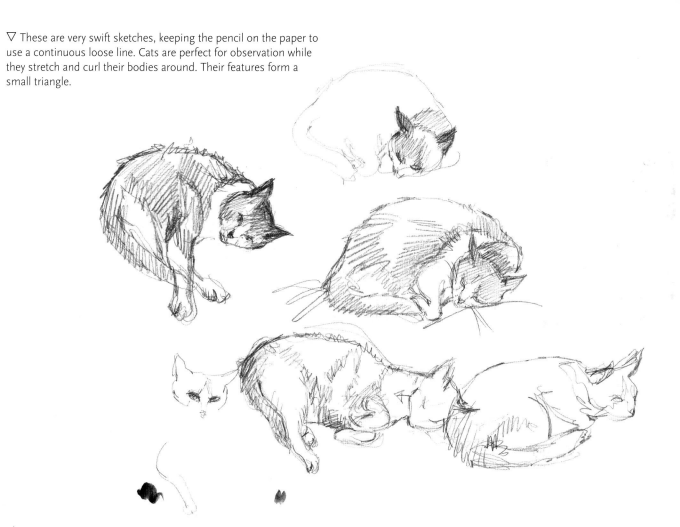

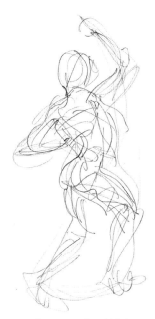

Here the gestural wobbly line is trying to follow and convey the movement.

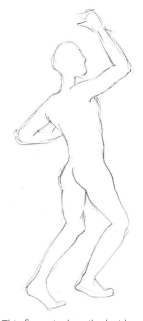

This figure is described with a very controlled pencil contour. The rapid scribbly line shown left conveys movement, while the simple line here freezes the figure in a position.

Gestural drawing

This style of drawing is a looser, freer method that entails holding the drawing tool, whether it is a brush, pencil or pen, less tightly and further up the handle. Standing back from the paper encourages you to look at the whole drawing and also stops you from working tightly and losing sight of the relative scale of the different elements.

Gestural drawing is a way of speeding up as you can't focus on details, so it's useful for making rough sketches of groups of people who are likely to move, for example. The lighting during a day will change so you can also explore that swiftly.

Draw not what the subject looks like, nor even what it is, but what it is doing – this style is all about the energy of the drawing, not reproducing the subject as accurately as you can. It is suitable

for drawing any object, but is especially good to create the mood of a swift glimpse of a landscape, a corner of the room, or a quivering wild flower.

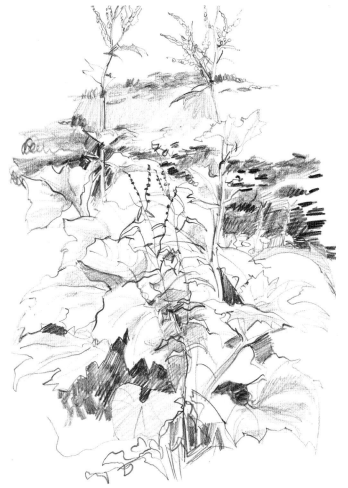

▷ This is a very free, gestural version of a plant. It shows the basic growth pattern and includes sketchy tonal areas.

▽ On the left, a contour drawing describes the form of the hand with a simple line; on the right, a gestural drawing gives a sense of action.

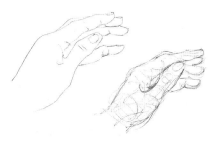

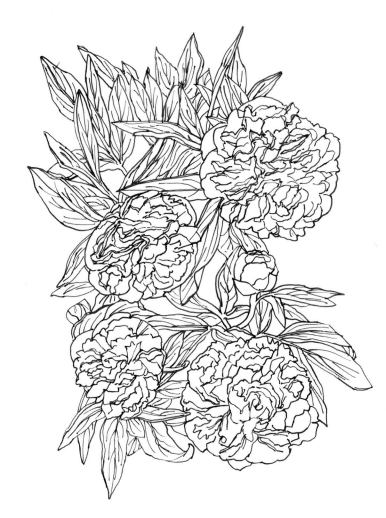

In this contour drawing of a peony, a very fine pen follows the edge and the form. Excellent for botanical studies, it's a very decorative style with the veins on the leaves carefully drawn with an exactitude that doesn't suit everyone.

Combining different drawing styles

In these drawings the contour, continuous and gestural styles have been combined to a greater or lesser degree. For example, the coffee pot had tonal areas added as they felt needed. This is where an open mind and eye are needed, which is the fun side of drawing.

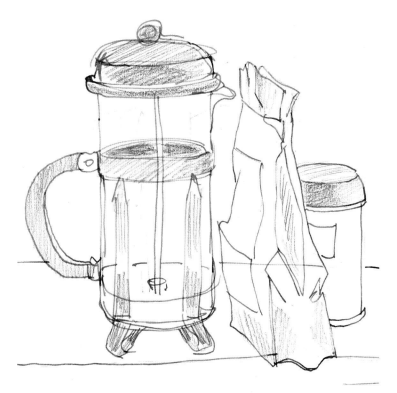

△ Here a contour drawing has a touch of tone added in pencil.

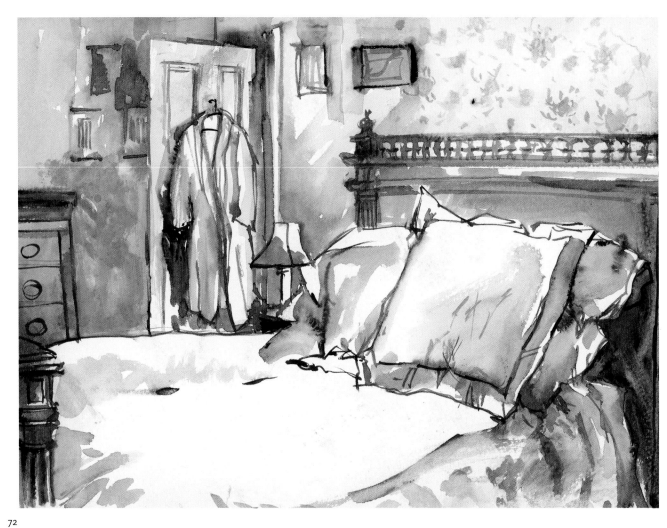

Chapter 7

Subjects to draw

Once you start to look at objects with an artist's eye, you'll discover little that isn't worth your attention for a drawing. Whether you are attracted by its textures or contours, nearly any object, however mundane, will offer plenty of interest and a chance to practise your skills. But of course we all have our personal preferences, whether they are for the natural world, urban scenes, people or animals. In this chapter you'll discover how to tackle these major themes.

◁ I liked the formality of the ornate bedhead in contrast to the intimacy suggested by the invisible presence of a person, owner of the dressing gown and the generous pillows. The watercolour washes help to show the folds and hang of the bed linen.

Trees

While trees may seem very complicated, if you examine a sprig of parsley or a broccoli head you will see what is effectively a miniature verson of a foliaged tree. What you need to do is look for the overall shape of the tree rather than try to describe individual leaves and branches. In the distant landscape, trees become compact shapes, but even when they are nearer you still need to avoid putting in a lot of detail and focus more on edges.

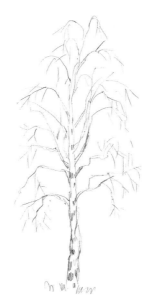

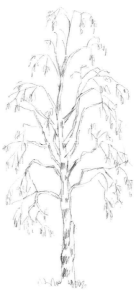

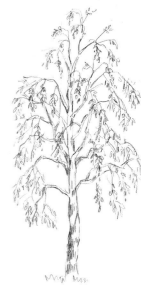

STAGE 1
Used delicately, pencil can convey the refined slenderness of a silver birch. Draw from the base of the tree, marking out the distinct darker pattern on the trunk. Map out the basic skeleton shape of the drooping branches.

STAGE 2
Continue adding a few marks for the leaves on the finer branches.

FINAL STAGE
Add more leaf shapes, maintaining the drooping habit of the tree.

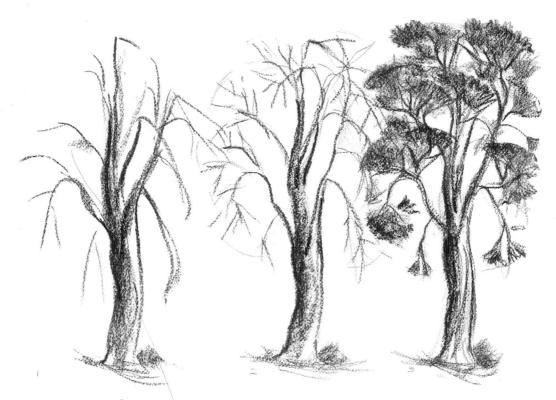

STAGE 1
Using charcoal, start from the base of the trunk and swoop upwards to form finer branches, using the side of the charcoal as well as the tip. This stresses the solidity of the form. Notice how some of the branches grow towards you.

STAGE 2
Add the finer branches fanning out from the main outline.

FINAL STAGE
With the side of the charcoal, mass in the broad foliage shapes towards the end of the branches.

A brush pen makes broken marks which work well for leafy trees – they give the impression of leaf canopy with plenty of light showing through.

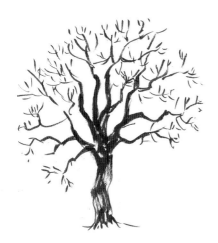

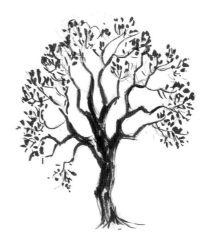

STAGE 1
Using the brush pen, start from the base of the tree and flow up to the skeleton of the branches, showing how they become finer at the edge of the whole shape.

STAGE 2
Add varied marks for the leaves around the crown of the tree shape.

FINAL STAGE
Continue making marks, overlapping them towards the centre so that the tree builds up into a more solid shape.

Watercolour is good for flowing, compact shapes such as that of the cypress.

STAGE 1
Mix blue paint with a touch of reddish-brown and, starting with the trunk, draw upwards to create the underlying structure of the tree. Break up the strokes to suggest the branches showing through the foliage.

STAGE 2
Fill out the foliage shape, mixing the paint with plenty of water.

FINAL STAGE
Further build up the body of the foliage, allowing yellow to blend into the wet blue paint, turning it greener.

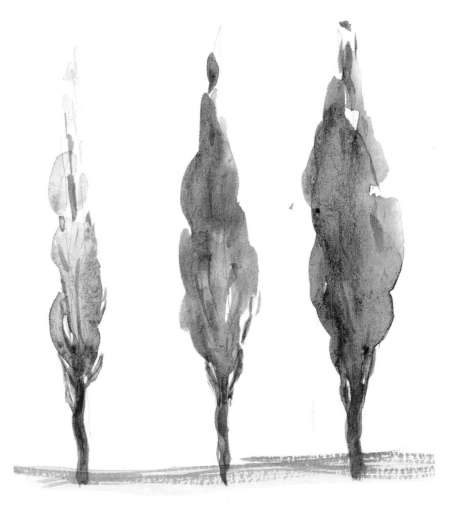

Landscapes

Drawing from the landscape is a visual gift – it is a way of intensely experiencing the natural world by being at one with it while you try to express it through your drawing.

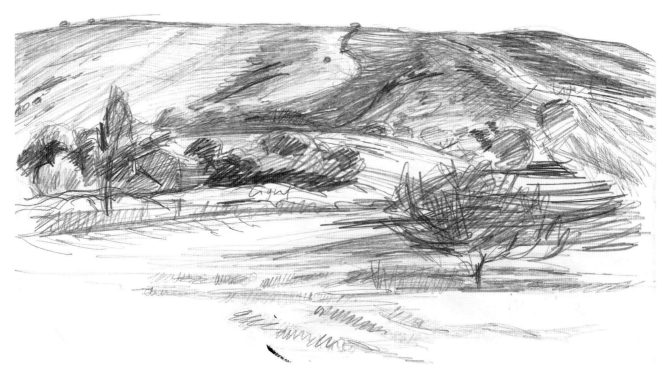

The elements of light and atmosphere are constantly changing, so you have to respond with rapid studies. It is a very good subject with which to experiment with your materials and find out what they can do. For example, charcoal works well rubbed in for cloudy moody skies, while a more delicate line can indicate a clear, sunny day. The challenge is to see and bring out the broad shapes and convey them with line and tone.

The landscape has been carved out by the elements, from ancient glaciers to today's rivers and streams. Use line to create the basic layout, showing the main features. Then, to convey the distance, observe the way the tone changes from the foreground to the background. Atmospheric haze mutes colours, tones and details, so that far views lack the clear definition of the foreground.

This drawing has two views, one close and the other more distant. I was intrigued by the lines that the sheep create on the hillside and the relatively treeless nature of England's South Downs. The drawing is all about the contour of the land, with the marks following the curves just as they might on a map.

For this pastel drawing I used paper of a sandy colour as that was dominant in the landscape. There are places where the paper shows through, particularly in the sky where a broad, sweeping, light touch differentiates it from the busier path and fields, which are described with marks that are more broken.

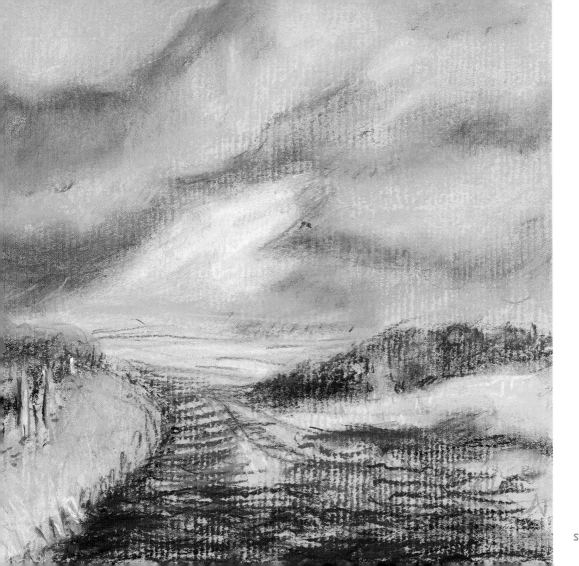

Urban landscape

The contrast of soft foliage and hard surfaces as a subject matter is possibly around the corner from where you live, or even visible from your window. A walk to the shops along a tree-lined street or the corner of a park with a path offer ideal subjects for drawing, with a more solid focus than an open landscape.

Clear lines of paths, roads, buildings and canals help to give structure to the drawings, with the organic curves and softer textures of grass, trees and plants helping to achieve a balanced composition.

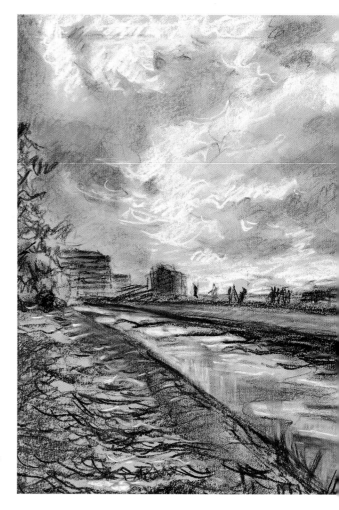

▷ The diagonal of the canal leads the eye into the drawing and stresses the perspective, the flatness of the landscape and the inclement weather. Charcoal, excellent for creating mood, is used here with tinted paper to provide the mid-tones and white chalk for the highlights. The buildings and foreground are just suggested with a few lines as the sky is the focus of the drawing.

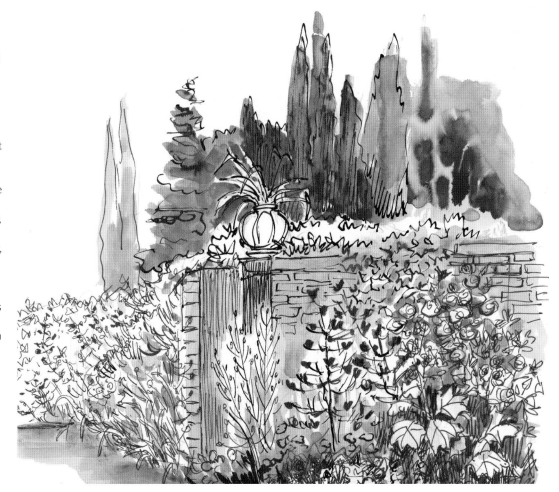

▷ This swift, loose drawing in pen and wash has simplified marks to describe the foreground plants and give the impression of a walled garden. The trees are the darkest wash, signifying their tonal value and the fact they are more distant. The plants in the border, which are various and impressionistic, tend to appear darker at the base. This helps to show the shapes of leaves and flower heads. The spaces between the trees are less dark to reveal the definite shape of the cypresses.

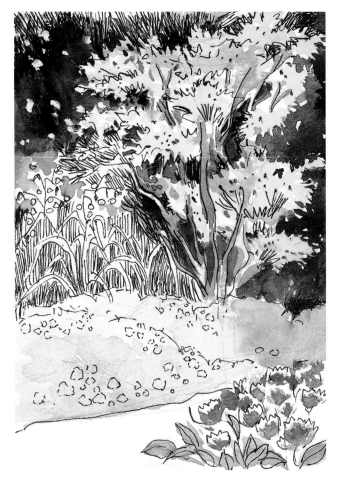

Gardens

Even if you don't have a garden, the chances are that there is one nearby to draw – a neighbour's, a park, or a notable garden with public access. The more formal ones have interesting architectural details such as a flight of steps, walls, ornamental urns, benches and statuary, all of which provide structure to the composition. A corner of a flower bed is fun but less defined, so you need to describe clearly the different proportions and shapes of the plants. Observe the nearest plants and define their edges; those further back can be more impressionistic.

◁ Blue and yellow flowers in pen and ink with coloured watercolour. The darkness was exaggerated behind the shrub to reveal the flower shapes clearly. There is always room for a little bit of invention or artistic licence to make a drawing work well.

▷ This pen drawing of a garden path is very stylized, with clean linear work rather than loose marks that invite the viewer to interpret them.

▽ Working from a window offers a broader view, where the plants appear smaller as you go down the path to the gate. The fun in this pen and wash drawing was in forcing the leaves to stand out by putting a wash around them and emphasizing the shadows. The marks are simplified to suggest different shapes of foliage.

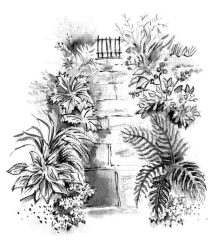

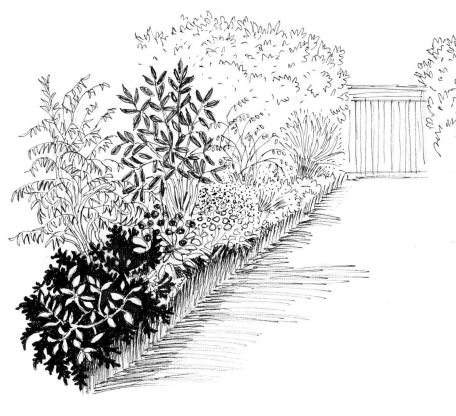

Pencil sketches of spring hedgerow plants,
showing a selection of different flower shapes.

Drawing flowers

For floral studies you need to use a slightly more acute analytical eye and look for the basic forms that underlie the pattern of growth. Even though nature offers myriad leaf and flower shapes that often seem very complex, you can reduce them to a simpler series of shapes. Initial rough sketches will help you to see the structures more clearly.

Shown here are sketches of bluebells and euphorbias that simplify their growth patterns.

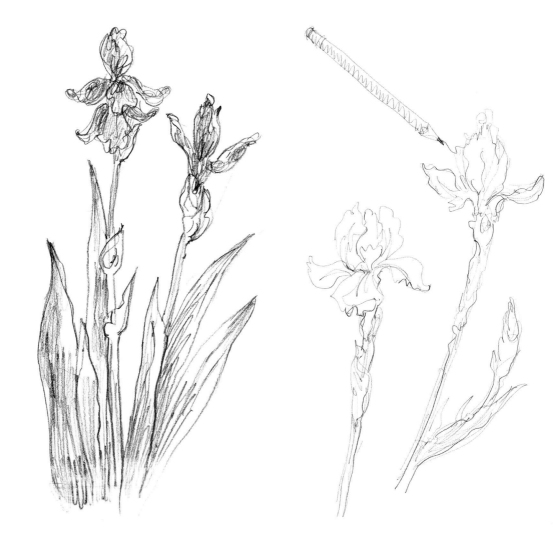

▷ In these pencil drawings of an iris I was exploring the twists and turns of the buds.

▷ My drawing of an iris in pencil and watercolour has been influenced by Japanese art, which often takes the image out of the rectangle.

▷ Here (far right) I paid particular attention to the delicate serrations of a cranesbill's leaves.

Drawing vegetables

Vegetables come in all kinds of interesting forms and textures, and here I have looked at some in an allotment. If you don't have the chance to draw vegetables in growth, some greengrocers sell their produce untrimmed, with the leaves still on, giving you a range of truly enticing subjects.

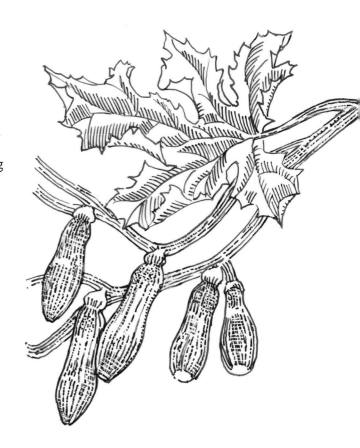

▷ A pen and ink drawing that emphasizes the different textures is an excellent way of expressing the beautiful marking and serrated leaves of a courgette plant.

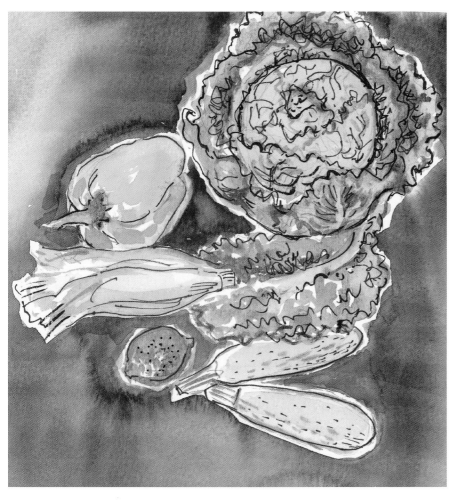

◁ Cabbage, yellow pepper, courgettes, lime and chicory drawn in pen line and watercolour. The network of complicated lines on the cabbage was drawn relatively loosely in pen line. To bring out the contrast in the green and yellow tones in the vegetables, I opted for a red background.

Buildings

When you set out to draw buildings on the spot you'll probably encounter a few practical problems such as traffic, people hurrying past you and so on. To start with, attempt a quiet street or square locally even if you think the architecture is ordinary. This may attract attention from passersby wanting to see what you are doing, but if this bothers you, simply place yourself against a wall so that no one can peer over your shoulder. Alternatively, look for houses in the country, where you'll find a range from grand homes to cottages.

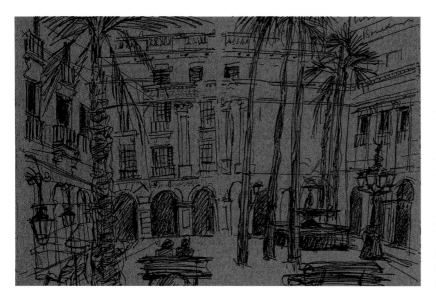

◁ This pen drawing on red paper of the Plaza Reale in Barcelona is really fast and gestural in style, picking out a few relevant details such as arches and lights to emphasize the fact that the architecture is of a square.

▷ Here I used a combination of ink, watercolour and wash. The shadows are important to reveal the rounded shape of the extension and give the building solidity. The style is gestural to capture the light as quickly as possible.

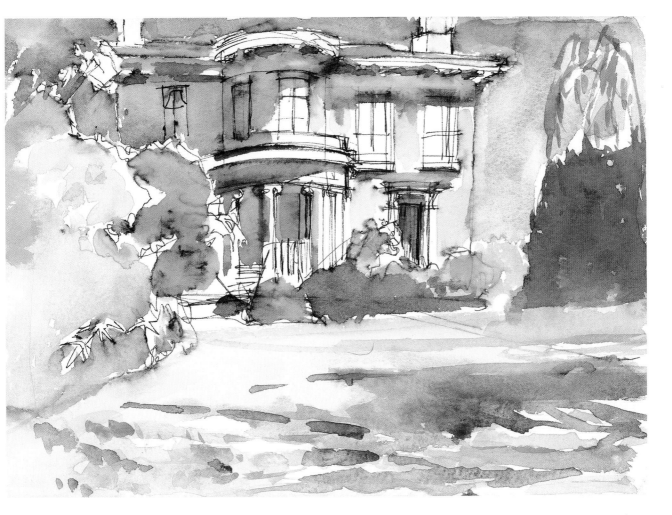

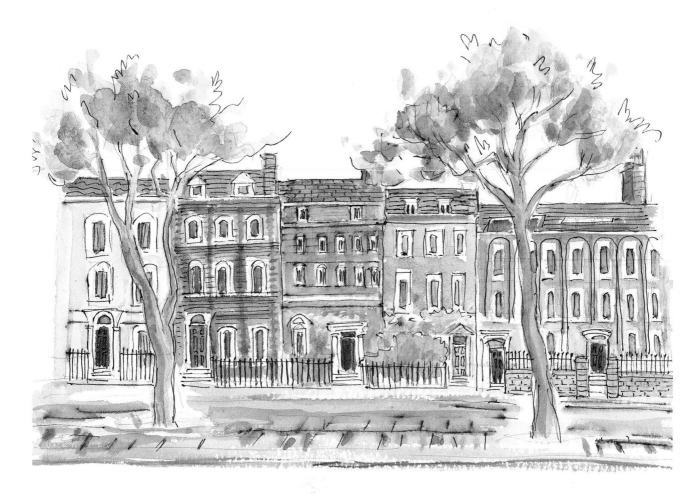

On the street

Whether they are Victorian terraces, modern high-rise locations or rows of shop fronts, all streets have qualities and quirks to attract the artist. It is often easier to work from photographs rather than stand on the spot, particularly if the street is busy with people and traffic, and this is perfectly acceptable. Both of the drawings here show a fairly simple viewpoint, so the challenge is in the detail. Watch for the spaces between windows and the height of the doors in relation to the size of the building. As they are more or less on a grid, it's helpful to lightly draw the verticals and horizontals so that they are ready to be developed into a drawing.

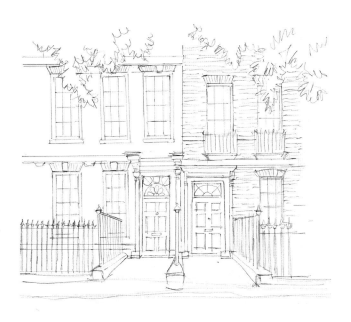

△ A close-up view in pencil presents more of a challenge as accuracy becomes important. If you find straight lines tricky, use a ruler. Keep things simple rather than risk cluttering the drawing with every little detail.

◁ This is a straight-on view of a typical terrace of town houses. I like the slight differences in roof height and architectural detail, such as the size of the windows and the brickwork. The trees help to establish the scale.

Street scene in different materials

The idea here is to find the most effective way to tackle a street scene from a high eye level and to practise with different materials. My view is of a curved street with people and traffic and the drawing marks needed to define the patterns of road signs and the contrasting building styles. It's not always possible to draw from a vantage point such as this, but looking from any upper-floor window will give you ample drawing material as you'll get a fresh view of how visually surprising the city can be. If you don't live in a city built on a grid, the challenge is how to convey the twisty curves of the streets and the range of different architecture.

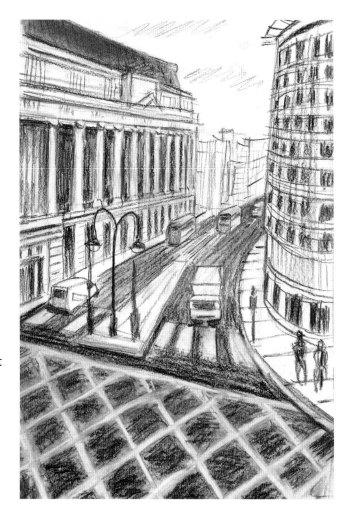

▷ In this charcoal drawing, I used an eraser to make the criss-cross lines of the junction area on the road in the foreground.

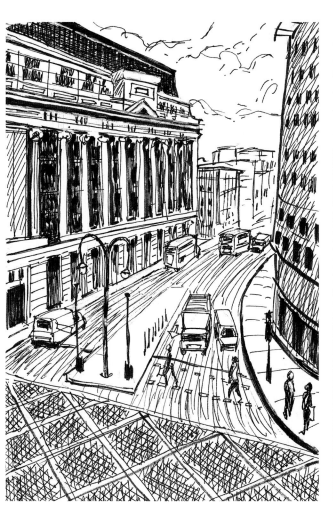

◁ This drawing is in pen and ink, using cross-hatching and dense lines to convey darker tones.

▽ Here I used HB to 6B pencils, conveying tones by varying the grades of lead and the pressure I applied.

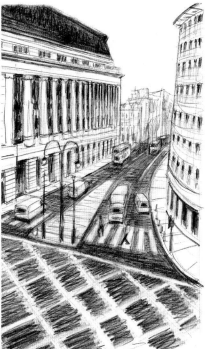

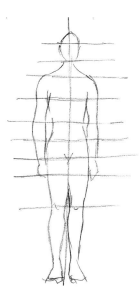

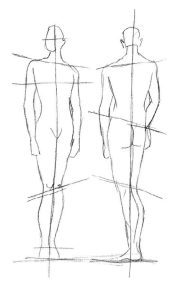

Drawing figures

This can be daunting for novice artists, since the human figure is a complex shape. However, if you try to be objective and do not allow yourself to become confused by the details of the facial features and hair, approaching the figure instead as a series of shapes that go into complicated positions, you may find this an enjoyable subject. The ideal way to start is at home when friends and family may be quite immobile watching TV or reading. This will give you longer to capture them in a drawing and puts less pressure on you as their focus is elsewhere and they won't become impatient for you to finish.

This proportional diagram divides the figure into sections so that you can see how to plot the whole shape, rather than just try to follow the contour edge. The standard measurement for proportions is that the height of the body is 7½ heads, but the overall proportions can vary.

Here the figure is standing with the weight on one foot, which causes the angles of the body to change. A tilt is usually counterbalanced by a tilt in the opposite direction – it's subtle but worth stressing.

▷ Sketching figures can be tricky when they are in motion, though you can take photos to use for reference. I chose to draw people in a queue because they are relatively still and more interested in getting to the front of it than in noticing you sketching. What makes the scene work is the overlap of the figures and the slight change of scale. Then I looked from the back of the queue (far right), when of course the proportions changed and the people who were smallest in the first picture now became the largest.

▷ Watch figures walking – don't try to draw until you see the rhythm. Note that one leg will appear to be shorter than the other as they take a step.

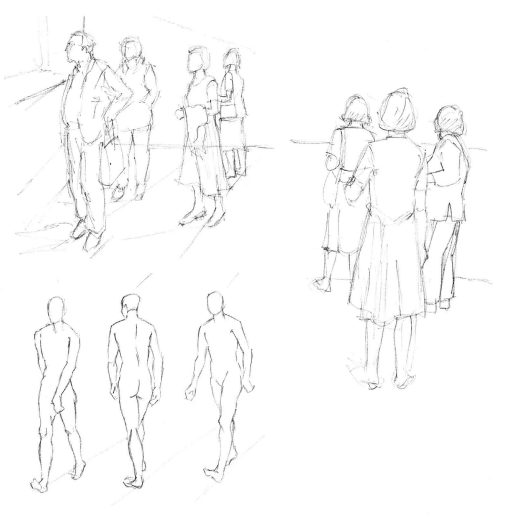

Figures in action

If you want to be more adventurous, try sketching people singing, dancing or playing music. It is a good idea to carry a sketchbook everywhere with you, so that you get into the habit of sketching people doing many different things.

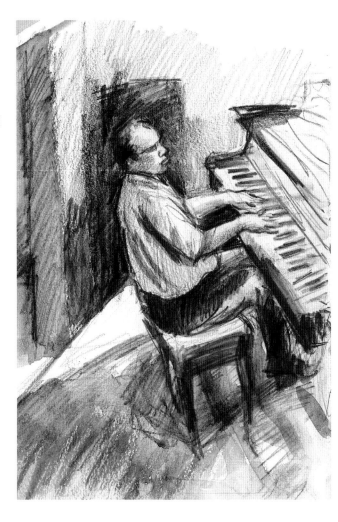

▷ I used watersoluble pencil for this scene in a jazz café. The viewpoint was especially interesting as I was sitting above the pianist.

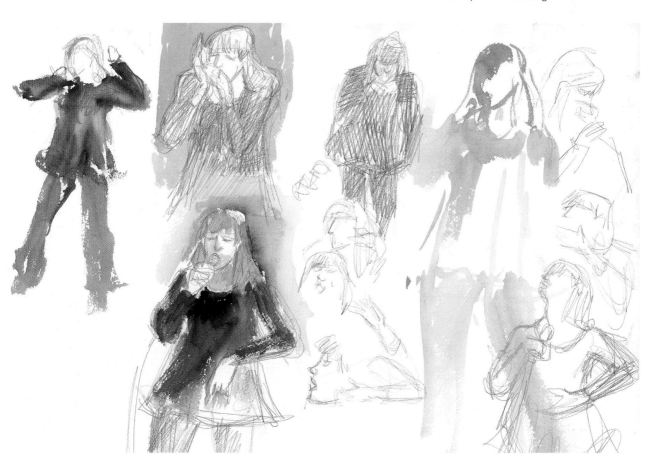

▽ I used pencil and watercolour for these sketches of a gig. Both mediums are ideal for swift, expressive drawings.

Catching quiet moments

People don't have to be doing something interesting to make an interesting drawing; when they are relaxed or even asleep you can make drawings that convey the intimacy of the moment. Once you become familiar with how figures fall into various poses you will be able to draw fluently. A mirror at home is useful to check certain positions on yourself.

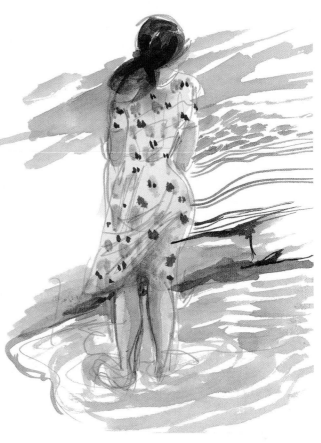

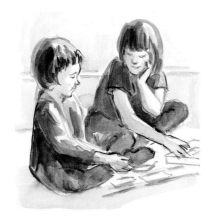

▷ Two sisters playing are captured here in black watercolour. This is a quiet little scene so needed a low-key approach.

△ Pencil and watercolour were ideal for this informal seaside drawing. The patterned dress demanded a splash of colour.

▷ I drew this man with his laptop in front of the TV in pen and wash, which is useful to achieve tone and texture.

▽ For the couple in bed, I chose washes of ink as the best technique for the folds of the bedlinen.

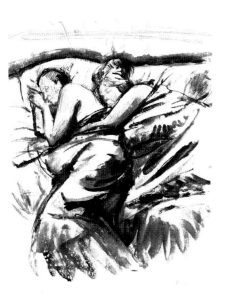

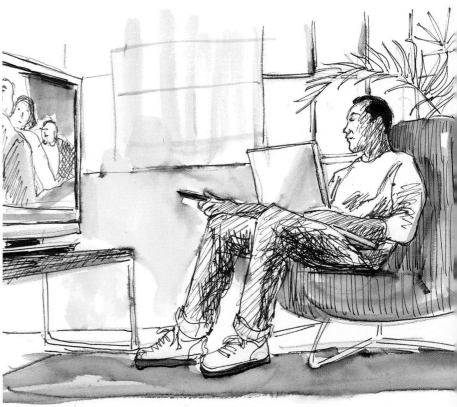

Interiors

The easy way to make a start with interiors is to draw your own home with its familiar objects.
Try just a corner with a few straightforward objects at first, then move onto a larger view.

For a sketch that will take a long time, it's best to find a view that won't be affected by a change in light and shadows as the sun moves across the sky. No room is uninteresting to draw, even if it may not contain your favourite furnishings and possessions.

For other interiors that are peaceful enough for you to draw relatively undisturbed, try churches, local museums and of course art galleries.

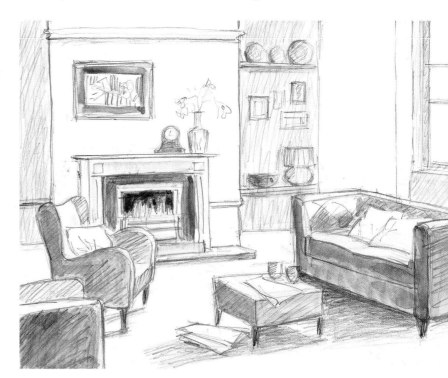

◁ The perspective here is fairly basic, with the lines of the sofa parallel with the little table. Drawing a room that's uncluttered, like this one, will always offer you the easier option. I could have focused on just a section from this composition, so look through your viewfinder to find possible close-ups from this version. I used pencil and wash here.

▷ This is straightforward one-point perspective through to the altar, with the stones and chairs diminishing in size. The tricky angles of the chairs are merely suggested. I liked the sombre grey from pen and wash warmed up with the red chalk details.

Of all the rooms in the home the kitchen is one of the most interesting for an artist, with the huge variety of shapes from cooking utensils to tables and chairs. They all need to be drawn in proportion with each other as well as the basic structure of the room. There is always the implied human presence and human scale; interiors are a visual historical record of where and how we live.

Atmosphere implied through lighting and interesting use of materials can bring an interior to life. Look for doors that allow a glimpse of a garden or courtyard as well as windows that give unusual light effects and views beyond.

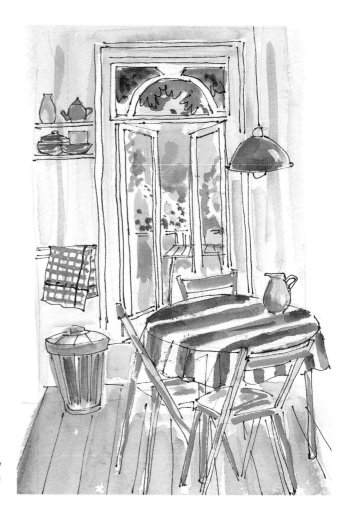

▷ Drawn in pen line and washes of watercolour, this loose, quick sketch uses the portrait format as the French windows influenced the overall shape of the drawing. Spontaneous drawings such as this often work well with colour casually placed rather than carefully filled in, leaving the white paper to emphasize the brightness of the sunny moment.

▽ It was fun to use little dashes of colour and pattern in watercolour here to liven up the drawing. The pencil line was loose and sketchy, as I wanted to make it look like a day in the life of a home, rather than an accurate representation. My viewpoint was quite a high one, slightly looking down on the room.

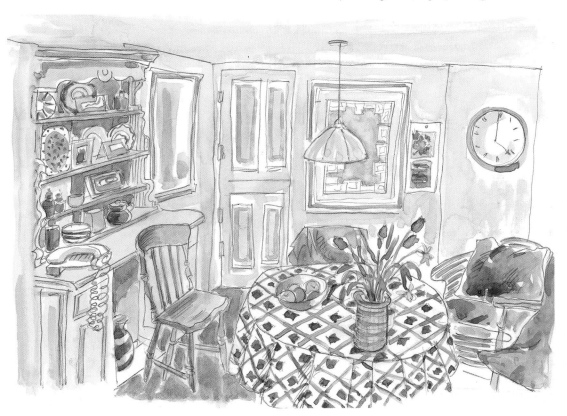

Animals

The obvious problem with animals is that they tend not to stay still except for when they are sleeping. Swift sketches that try to catch them in motion are interesting and fun to do, but for a more considered drawing you may have to resort to photos. I decided to combine a photo of a fox in my garden with a fleeting glimpse of it. The challenge is to try to capture the sense of movement, texture and character in your drawing. A few lines to show the form of your pets as they sleep, stretch and eat are very telling.

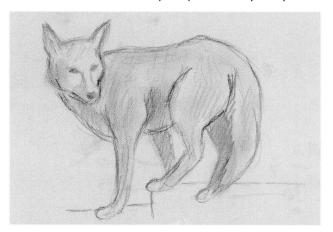

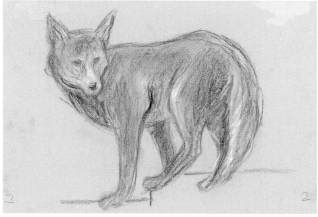

STAGE 1
Using charcoal on tinted paper, draw the shape of the fox, noting the placing of the limbs and the cast shadows that show one limb in front of the other.

STAGE 2
Add heavier tones and texture with red chalk and a touch of white for the few areas that have caught the light.

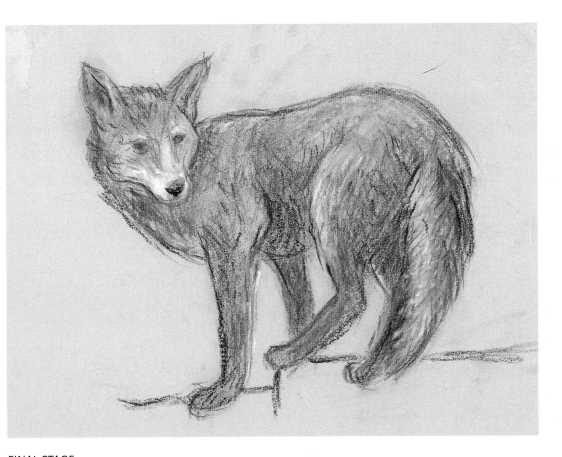

FINAL STAGE
To finish the drawing, roughen up the furry texture with broken marks and tighten up the features of the face.

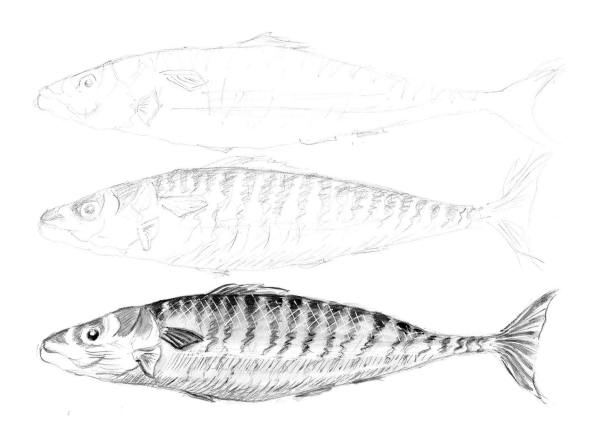

For this fish I used pencil, wash and a white uniball pen. I began by drawing the basic narrow oval shape and marking the fins, scales and stripes. I strengthened the patterns with black watercolour then finished the drawing with a white uniball, which appears to be the only white pen that can work successfully over dark marks.

The drawing of the fish could also be considered as part of a still life; a range of ingredients along with a chopping board and knife, for example, have often figured as still life compositions.

Farms are good places to watch animals. Here, fast sketching was necessary. Interrupted drawings can often be resumed a little later when an animal repeats a characteristic movement.

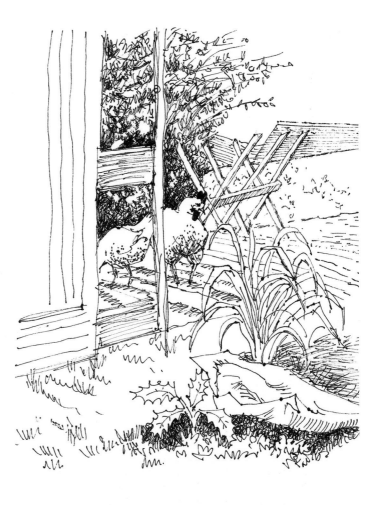

The dark areas around the chickens and in the foreground under the plastic bag draw your eye into the space. I enjoyed all the different textures that I had to represent in this drawing.

Index